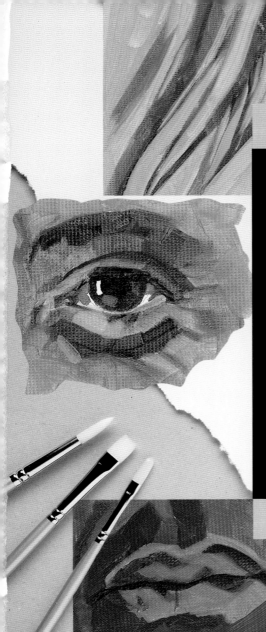

The
Portrait
Pocket
Palette

Ian Sidaway

CHARTWELL
BOOKS, INC.

A QUARTO BOOK

Published by Chartwell Books
A Division of Book Sales, Inc.
14 Northfield Avenue, Edison,
New Jersey 08837

This edition produced for sale
in the U.S.A., its territories and
dependencies only.

ISBN 0-7858-0579-6

This book was designed and
produced by
Quarto Inc.
6 Blundell Street
London N7 9BH

Art Director Moira Clinch
Senior Art Editor
Clare Baggaley
Designer Sallyann Bradnam
Editorial Director
Mark Dartford
Senior Editor Sally MacEachern
Editor Helen Douglas-Cooper
Illustrations Ian Siddaway
Picture Research
Giulia Hetherington

Typeset in Great Britain by
Genesis Typesetting
Manufactured by Bright Arts
Pte Ltd, Singapore
Printed by Leefung-Asco
Printers, China

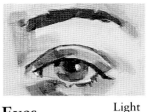

Eyes

Light

Medium

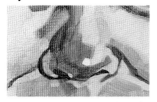

Noses

Light

Medium

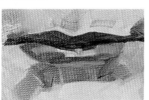

Mouths

Light

Medium

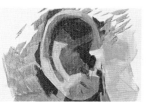

Ears

Light

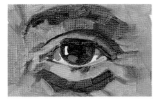

Medium

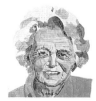

Pulling it together

Medium

CONTENTS

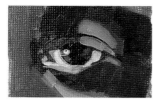

Dark

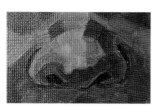

Dark

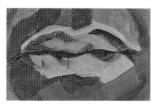

Dark

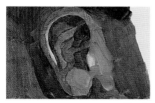

Dark

Dark

How To Use This Book

THE AIM OF THIS BOOK is to provide the artist with an easy, at-a-glance guide to various color and mixing combinations that between them cover a diverse range of skin coloring for different age groups. This book does not claim to cover all possibilities, but shows that even a limited choice of colors can give a selection of possible mixes for light, medium, and dark-skinned people. There is no correct way to paint flesh. Each artist finds his or her own approach, and you should always be prepared to experiment with different combinations of colors.

Structure

The book is divided into five sections. The first four focus on individual features – eyes, noses, mouths, and ears. The final section shows you how to pull it all together as you paint the face and hair. Each section begins with a spread showing how light, angle, and tone affect the way you see and paint features. This is followed by three spreads on painting light, medium, and dark skins. The final section includes three extra spreads on painting hair.

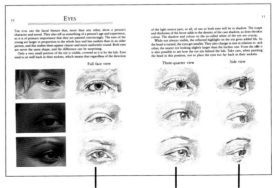

Light, medium, and dark skins *Full face view* *Three-quarter view* *Side view*

5

Light skin spread

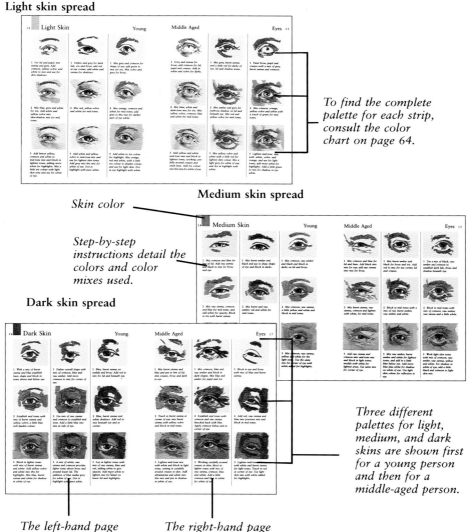

To find the complete palette for each strip, consult the color chart on page 64.

Skin color

Medium skin spread

Step-by-step instructions detail the colors and color mixes used.

Dark skin spread

Three different palettes for light, medium, and dark skins are shown first for a young person and then for a middle-aged person.

The left-hand page shows a young person's features.

The right-hand page shows a middle-aged person's features.

SKIN COLOR

Skin tones and colors can be mixed from many different tube colors. However, most professional artists tend to work with a palette of around ten or twelve colors, and through experimentation they learn to mix all the colors they need. The ten colors below plus white make a good starter palette. Beneath are a few mixes using those basic colors.

Basic palette

Cadmium red	Alizarin crimson	Cadmium yellow	Lemon yellow	Yellow ocher

Burnt sienna	Raw umber	Ultramarine blue	Cobalt blue	Payne's gray

Mixes

Burnt sienna Ultramarine blue	Alizarin crimson Payne's gray Raw umber Titanium white	Cobalt blue Burnt sienna Cadmium red Titanium white	Cadmium yellow Cobalt blue Burnt sienna	Cadmium red Yellow ocher Titanium white

Yellow ocher Alizarin crimson Cobalt blue Titanium white	Alizarin crimson Lemon yellow Titanium white	Burnt sienna Cobalt blue Titanum white	Raw umber Cobalt blue Titanium white	Cadmium red Cadmium yellow Titanium white

Alizarin crimson Cadmium yellow Titanium white	Yellow ocher Alizarin crimson Titanium white	Yellow ocher Payne's gray Titanium white	Burnt sienna Lemon yellow Titanium white	Cadmium red Lemon yellow Titanium white

The achromatic scale is a tonal scale that runs from black through gray to white in a series of slight, evenly graduated steps. All colors can be matched to a tonal value on this scale. Dark blue is close to black on the scale, as is dark red, but they are totally different colors. Look at a black and white photograph and you will see how colors assume a tonal value. An understanding of tonal value is central to good portrait painting if a correct degree of modeling is to be achieved. On an evenly lit face, the tonal values of colors are close together, which will flatten it. If the face is lit from one side, that side will be light and the other side in shadow, resulting in a wide range of tonal values that makes the face more three-dimensional and gives a sense of drama. It is prudent to bear this in mind when posing your subject.

achromatic scale

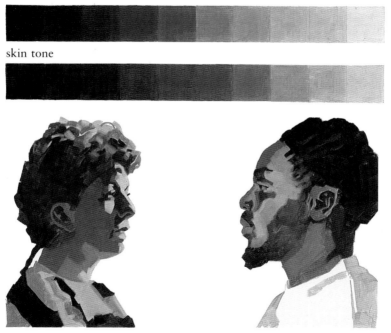

skin tone

Dramatic lighting makes light skin look dark.

Reflected light makes dark skin appear light in tone.

TECHNIQUES

OIL PAINT IS the traditional portrait-painting medium. However, the same techniques that are used with oils can also be used with acrylic paint. The one unique characteristic of acrylic paint, its fast drying time, can easily be overcome by adding a retarder to the mix.

ALLA PRIMA

Working directly onto the support with little or no preliminary underdrawing and completing the painting in a single session is known as alla prima. The colors and tones are laid side by side, more or less as in the finished painting.

◄*If the paint is mixed to a buttery consistency and applied wet-into-wet with quick clean strokes, an alla prima painting will have a lively surface texture showing the brushmarks left by the quick direct application of the paint.*

GLAZING

Glazing consists of building up layers of transparent paint over an underpainting. Each layer of color modifies and darkens the one beneath, giving colors a degree of luminosity and depth that is unobtainable by mixing colors on the palette.

*Glazing with oils is a slow process►
because each layer needs to dry completely before the next is applied. The process will be quicker with acrylic as the paint dries fast. Always use a glazing medium to thin oil paint, not just turpentine.*

You can begin a portrait by making a tonal underpainting using just one color; any neutral color is suitable. Traditionally, terre verte was used, but raw sienna or Payne's gray are equally acceptable. Render the whole subject in light and dark tones, applying the paint thinly. When this layer is dry, rework the subject using the full palette of chosen colors. Quick-drying acrylic paint is ideal for the tonal underpainting.

◀*This process allows you to assess the image in two distinct phases: first as tone only, in order to check that you have got the balance of tones and degree of modeling that you want; then in terms of color, the tonal values of which can be matched to the underpainting.*

BLOCKING IN

Blocking in is a form of loose underpainting in which you treat the subject initially as a series of flat shapes, working across the whole painting in approximately the right colors and tones using large brushes and thin paint. This allows you to assess and make changes to the composition and the basic drawing of the head before too much paint is applied. Continue the painting by building up form and color, gradually reducing the size of the brushwork, and concentrating on the details last of all.

Acrylics are an ideal medium to use▶
for blocking in. You can make changes as you go and then complete the painting in either acrylics or oils. If you are using oils for blocking in, work with thinner paint and allow the paint to become thicker in the final working.

EYES

THE EYES ARE the facial feature that, more than any other, show a person's character and mood. They also tell us something of a person's age and experience, so it is of primary importance that they are painted convincingly. The eyes of the young are larger in proportion to the whole face and less sunken than in an older person, and this makes them appear clearer and more uniformly round. Both eyes are never the same shape, and the difference can be surprising.

Only a very small portion of the eye is visible, covered as it is by the lids. Eyes tend to sit well back in their sockets, which means that, regardless of the direction

Full face view

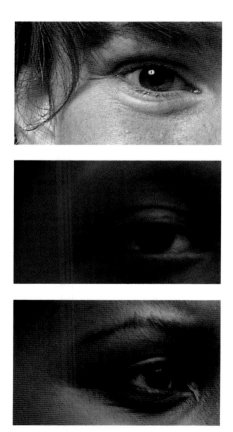
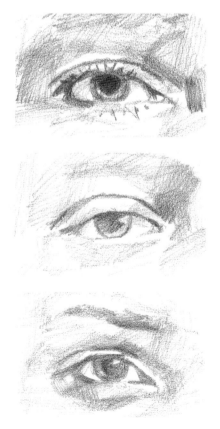

of the light source, part, or all, of one or both eyes will be in shadow. The shape and thickness of the brow adds to the density of the cast shadow, as does the skin color. The shadow and color on the so-called white of the eye are crucial.

While not always visible, the reflected highlight on the iris gives added life. As the head is turned, the eyes get smaller. They also change in size in relation to each other, the nearer eye looking slightly larger than the further one. From the side it is also possible to see how the eye sits behind the lids. Take care, when painting the head in this position, not to place the eyes too far back in their sockets.

Three-quarter view Side view

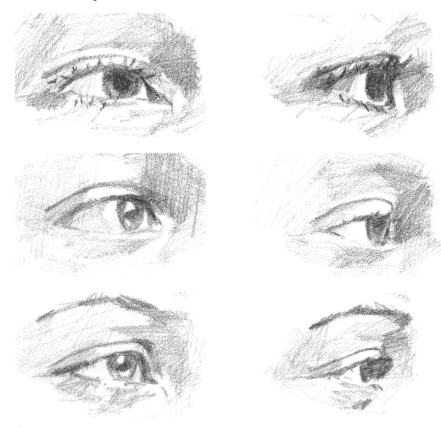

Light Skin Young

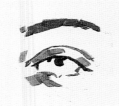

1 *For lid and pupil, mix sienna and gray. Add crimson, yellow ocher, and white to mix and use for skin shadows.*

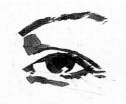

1 *Umber and gray for dark lids, iris, and brow; add red at eye corner; add white and sienna for shadows.*

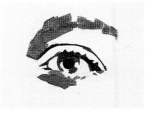

1 *Mix gray and crimson for shape of eye; add green to mix for iris. Mix ocher and gray for brow.*

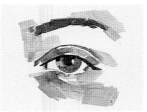

2 *Mix blue, gray, and white for iris. Add white and yellow ocher into skin-shadow mix for middle tones.*

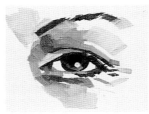

2 *Mix red, yellow ocher and white for middle tones.*

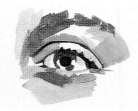

2 *Mix orange, crimson, and white for middle tones; add gray to this mix for darker part of eye white.*

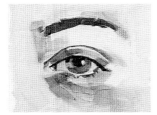

3 *Add lemon yellow, crimson, and white to middle-tone mix and block in lightest tones, adding more white for highlights. Mix a little iris color with light skin tone and use for white of eye.*

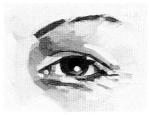

3 *Add white and yellow ocher to middle-tone mix and use for lightest skin tones. Add gray into this mix for white of eye. Dot in highlight with pure white.*

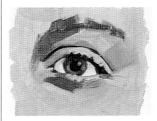

3 *Add white to iris color for highlight. Mix orange, red, and white, with a little iris color to deaden color, and use for light skin. Dot in eye highlight with white.*

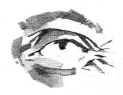

1 Gray and sienna for brow; add crimson for lid, pupil, and creases. Add in white and ocher for darks.

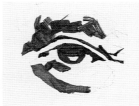

1 Mix gray, burnt sienna, and a little red for darks of eye, lid, and shadow areas.

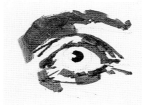

1 Paint brow, pupil, and creases with a mix of gray, burnt sienna, and crimson.

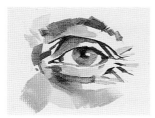

2 Mix blue, white, and dark-tone mix for iris. Mix yellow ocher, crimson, blue, and white for middle tones.

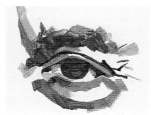

2 Mix umber and gray for eyebrow shadow on lid and beneath eye. Mix red and yellow ocher for middle tones.

2 Mix crimson, orange, yellow ocher, and white with a touch of green for middle tones.

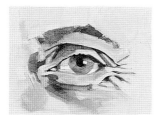

3 Add yellow and white to middle-tone mix and block in lightest tones, working carefully around creases and smile lines. Add in iris color for white of eye.

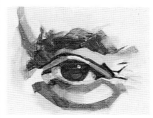

3 Mix yellow ocher and white with a little red for lightest skin color. Mix a light gray for white of eye, and dot in highlight with white.

3 Lighten middle-tone mix with white, ocher, and orange, and use for light tones; add more white for highlights. Add a little green to mix for shadow in eye white.

Medium Skin

1 *Mix crimson and blue for line of lid. Add raw sienna and black to mix for brow and eye.*

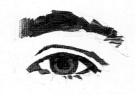

1 *Mix burnt umber and black and use to draw shape of eye and block in darks.*

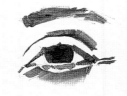

1 *Mix crimson, raw umber, and black and block in darks on lid and brow.*

2 *Mix raw sienna, crimson, and blue for middle tones, and add white for opacity. Block in iris with burnt sienna.*

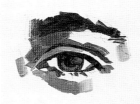

2 *Mix burnt and raw umber, red and white for middle tones.*

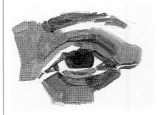

2 *Mix crimson, raw sienna, a little yellow, and white and block in middle tones.*

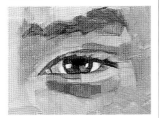

3 *Add raw sienna and white to middle-tone mix and block in light skin tones. Add crimson at cheekbone and below eye. Mix crimson and blue and touch in at corners of eye.*

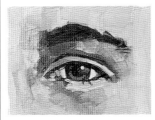

3 *Mix red, raw umber, and white and block in light tones, adding a little blue into this below eye. Mix red and blue for corners of eye; add white into this for white of eye.*

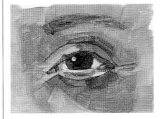

3 *Mix crimson, raw sienna, yellow, and white for the light tones. Use the same mix for corner of eye with white added for highlights.*

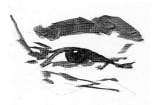

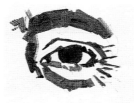

1 *Mix crimson and blue for lid and lines. Add black into mix for eye; add raw sienna into mix for brow.*

1 *Mix burnt umber and black for brow and iris. Add red to mix for eye corner, lid, and creases.*

1 *Use a mix of black, raw umber, and crimson to establish dark lids, brow, and shadow beneath eye.*

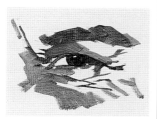

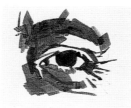

2 *Mix burnt sienna, raw sienna, crimson; lighten with white for middle tones.*

2 *Block in middle tones with a mix of red, burnt umber, raw umber, and white.*

2 *Block in middle tones with mix of crimson, raw umber, raw sienna, and a little white.*

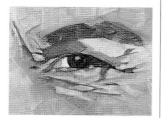

3 *Add raw sienna and crimson into middle-tone mix and block in light tones; modify with white for lightest areas. Use same mix for corner of eye.*

3 *Mix raw umber, burnt umber, and white for lightest tones, and add in a little blue below eye. Add more blue plus white for shadow on white of eye. Use light skin color for reflection in eye.*

3 *Work light skin tones with mix of crimson, raw umber, raw sienna, yellow, and white. For shadow in white of eye, add a little black and crimson to light skin mix.*

Dark Skin

Young

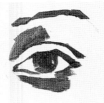

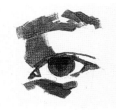

1 *With a mix of burnt sienna and blue, establish basic shape and block in tones above and below eye.*

1 *Define overall shape with mix of crimson, blue, and raw umber. Add more crimson to mix for corner of eye.*

1 *Blue, burnt sienna on eyelids and brow. Add red to mix for lid and beneath eye.*

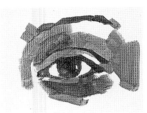

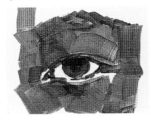

2 *Establish middle tones with mix of burnt sienna and yellow ocher; a little blue will deaden color.*

2 *Use mix of raw sienna and crimson to establish middle tone. Add a little blue into mix at side of eye.*

2 *Blue, burnt sienna, and white for shadows. Add red to mix beneath eye and at corner.*

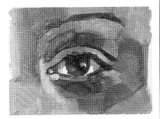

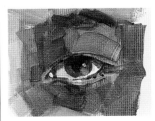

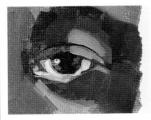

3 *Block in lighter tones with mix of burnt sienna and white. Add yellow ocher and white into this for highlights. Mix blue, burnt sienna, and white for shadow in white of eye.*

3 *A mix of white, raw sienna, and crimson provides ligher tones above brow and around lower lid. The addition of blue makes gray for white of eye. Dot in highlight with pure white.*

3 *Lay in lighter tones with mix of raw sienna, blue, and red, adding white to give opacity. Add more white to lighten mix for detail on lower lid and highlights.*

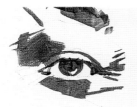

1 *Mix burnt sienna and blue and put in line of lid, skin creases, brow, and dark in eye.*

1 *Mix crimson, blue, and raw umber and block in dark shapes. Mix blue and umber for pupil and iris.*

1 *Block in eye and brow with mix of blue and burnt sienna.*

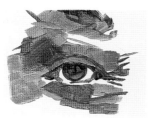

2 *Touch in burnt sienna at corner of eye: mix burnt sienna with yellow ocher; block in middle tones.*

2 *Establish middle tones with crimson and raw sienna knocked back with blue. Apply crimson below and at corner of eye.*

2 *Add red, raw sienna, and blue into previous mix and block in middle tones.*

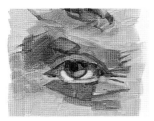

3 *Lighten middle-tone mix with white and block in light areas, cutting in carefully around creases in skin. Add ultramarine and white into this mix and put in shadow in white of eye.*

3 *Working carefully around creases in skin, block in lighter tones with mix of raw sienna, crimson, blue, and white. Add a little crimson and blue to white for white of eye.*

3 *Lighten middle-tone mix with white and burnt sienna for light tones. Touch in red at corner of eye. Use light skin mix with white added for highlights.*

MY GRANDMOTHER

Paul Bartlett
8 × 10 inches

THIS TINY PAINTING has a precious, jewel-like quality about it that reflects the obvious affection the artist feels for the sitter. The portrait is painted on masonite primed with several coats of traditional gesso, which is more absorbent than the modern, acrylic-based equivalent. Working with small brushes, the artist applies his paints with small strokes and dots, gradually building up the color and tone, the absorbency of the gesso ground dragging the paint from the brush. The paint is thinned with distilled turpentine, with a little oil medium added for the glazes.

▼ *Cadmium red and cadmium yellow are added to the previous mixture to warm it up for the shadow areas. The artist is greatly concerned with the effects that local and reflected color have on the tones and color found in the skin and has glazed the darker areas with these reflected colors.*

▲ *The light falling on the figure picks up and highlights the texture and color of the old lady's skin. Cool mixes based on titanium white, Naples yellow, and yellow ocher are used.*

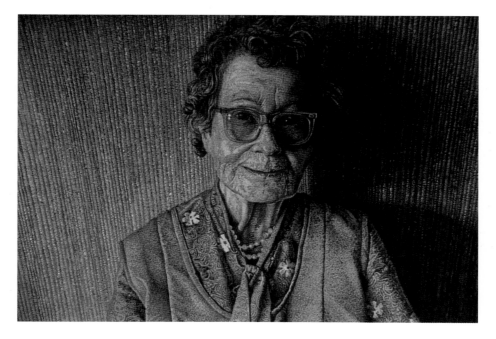

◄ *The blacks are mixed from a selection of browns and blues. Mixing black with darker colors can be effective, whereas mixing black with lighter colors alters their character.*

NOSE

UNLIKE THE MOUTH, the nose takes on a more defined and definite shape as the head is turned to the side. It also seems to get larger or smaller when viewed from different angles. Giving the nose dimension and form when viewed from the front seems to present the most problems, especially when the face is uniformly lit from the front and therefore flat. The following simple tips will help to give character to the nose. When the face is lit from the side and above, the base of the nose

Full face view

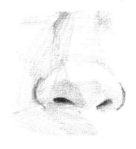

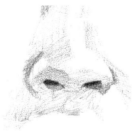

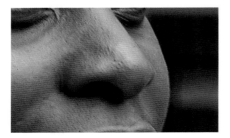
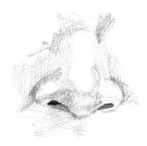

around the nostrils is thrown into deep shadow, with a lighter shadow down one side. The tip of the nose can be made to advance by putting a highlight there. The nose can also be made to project forward from the face by the shadow it throws onto and across the face. The bridge of the nose can be made to stand out through a contrast with receding, cool, dark shadows within the eye sockets.

Three-quarter view Side view

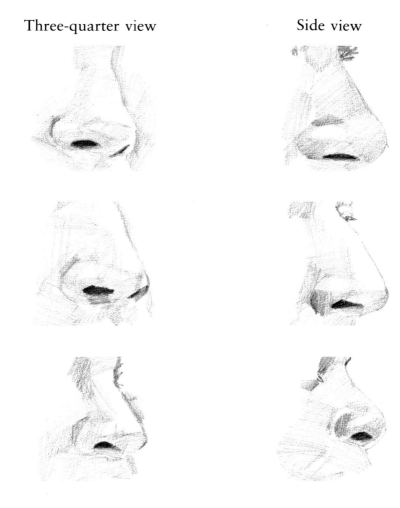

Light Skin

1 *Establish darks with red and umber. Darken with blue for nostrils and deep shadow.*

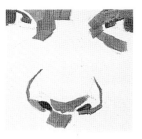

1 *Mix gray and crimson for dark of nostrils. Add raw sienna and white for shadows.*

1 *Work darks with sienna and lemon yellow. Add gray to mix for shadow below nose.*

2 *For middle tones, lighten dark mix with red, yellow, and white.*

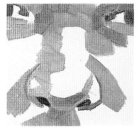

2 *Establish middle tones with mix of crimson, yellow, raw sienna, and white.*

2 *Establish middle tones with varied mixes of red, yellow ocher and white.*

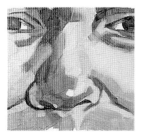

3 *Add blue to middle-tone mix for shadow beneath nose. Lighten with white, red, and yellow for cheeks and side of nose. Leave white ground as highlight on tip of nose.*

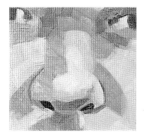

3 *Pale mix of crimson, yellow, and white gives lightest tone. Highlight with pure white.*

3 *Block in lightest tones with mix of cadmium yellow, red, and white, adding in a little of the darkest mix to deaden color. Highlight with pure white.*

1 *Work darks with umber and blue. Lighten with red for wrinkles and shadow.*

2 *Lighten dark mix with yellow and white to establish middle tones.*

3 *Block in lights with red and yellow mixed with varying amounts of white. Highlights in yellow mixed with white.*

1 *Crimson and sienna for shadows. Add gray to mix for dark of nostrils and shadow.*

2 *Establish lighter tones and shadows with varying mixes of sienna, crimson, yellow, and white.*

3 *Mix white and raw sienna for lightest tones. Add a little crimson to this mix and use for pink of nose.*

1 *Establish darks with mix of sienna and gray, lightened with sienna and white for shadows.*

2 *Mix red, yellow ocher and white for middle tones. Add sienna for shadow at side of nose.*

3 *Add white into previous mix for lightest tones. Add a touch of red to the mix and use for pink on end of nose.*

Medium Skin

Young

1 Mix umber and blue for nostrils. Add in yellow, crimson, and white for dark tones.

1 Umber and blue for nostrils. Add red and sienna for darks; add blue beneath nose.

1 Mix gray and sienna for nostrils. Mix sienna, crimson, and ocher for darks.

2 Mix sienna, yellow, and crimson for middle tones. Add in blue beneath nose and eyes.

2 For middle tones, add more red plus yellow to dark mix.

2 Mix sienna and ocher for middle tones; add ocher and crimson for cheeks.

3 Establish light tones with mix of yellow and white.

3 Mix raw sienna and yellow for light tones; lighten with white for highlights.

3 Mix yellow ocher, white, and crimson for the lightest tones, adding in more white for highlights.

1 Mix umber, crimson, and blue for nostrils. Mix sienna, crimson, and umber for darkest tones.

1 Red and sienna for darks. Add umber and blue to mix for shadow below nose.

1 Establish form and dark tones with mixes of gray, sienna, and crimson.

2 Crimson and sienna mix gives middle tones. Draw in wrinkles and shadow beneath nose.

2 Establish middle tones with varying mixes of sienna, red, and blue.

2 Varying mixes of burnt sienna, yellow ocher and crimson give mid tones.

3 Block in light tones using mix of sienna and yellow. Add white into this mix and use for highlights.

3 Block in lightest tones with mix of raw sienna and yellow, lightened with white for highlights.

3 Lighten middle-tone mix with white and yellow ocher for lightest tones.

Dark Skin Young

1 Mix red and gray for nostrils. To this, add orange, ocher, and red for darks.

1 Mix umber, crimson, and blue for nostrils. Mix crimson, orange, and sienna for shadows.

1 Mix burnt sienna and blue for nostrils. Mix in more sienna for dark tones.

2 Add Naples yellow and a little red into mix; deaden with a little gray.

2 Mix sienna and crimson with a little blue and white for middle tones.

2 Establish middle tones by adding burnt sienna and yellow into dark mix.

3 Add Naples yellow, orange, and a little red to previous mix for lightest tones. Add white and Naples yellow into this and use for highlights.

3 Mix orange, raw sienna, and white for lightest tones. Add a little blue to mix for highlight. Darken nostrils with mix of raw umber and blue.

3 Mix yellow with a little mid-tone mix for light tones.

1 Block in nostrils and darkest tones with mix of red and gray.

1 Mix umber, crimson, and blue for darks. Add a little orange for shape of nose.

1 Mix blue and burnt sienna for darks.

2 Red, orange, and yellow ocher deadened with gray give middle tones.

2 Sienna, orange, crimson, and white with a little blue give middle tones.

2 Modify dark mix with more burnt sienna and yellow ocher for mid tones.

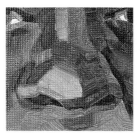

3 Mix orange, Naples yellow, and yellow ocher for lighter tones, and lighten with white for highlight.

3 Add white to mid-tone mix for light tone. For highlights use white, a little light-tone mix, and blue.

3 Add yellow into a little of the dark mix for lightest tones. Add blue into mix and use for highlights.

THE ITALIAN CONNECTION

Olwyn Tarrant
25 × 30 inches

THE PRIMED CANVAS is stained with a thin, light mix of burnt sienna. Once this is dry, the subject is drawn in with a darker mix of burnt sienna, using a thin bristle brush. Using large bristle brushes, the artist then blocks in the planes of tone and color that give the image form and structure. The palette of colors relates to the background and the overall desired ambience.

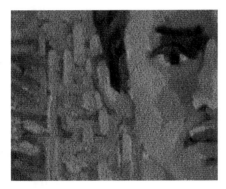

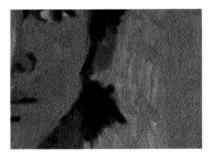

▲ *The warm, light skin tones are mixed from cadmum red, Indian yellow, yellow ocher, and titanium white.*

▲ *The light tones are modified with ultramarine blue, alizarin crimson, blue black, and raw sienna.*

◀ *The hair is worked with loose strokes of burnt sienna, blue/black, and a gray mixed by adding white to a blue/brown mix.*

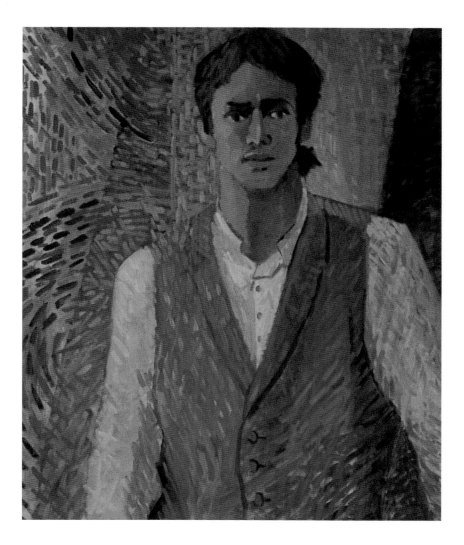

MOUTH

Along with the eyes, the mouth gives expression to the face. The complex muscle group that serves to animate the mouth is connected to and has a direct influence on the chin, cheeks, and nose, and so the rest of the face. Even a slight alteration in the shape of the mouth can change the look or apparent temperament of the sitter. The lips are not flat, but curl away and stand away from the face. This can be seen more easily from the side. The upper lip usually appears darker than the lower lip because its main surface is angled slightly

Full face view

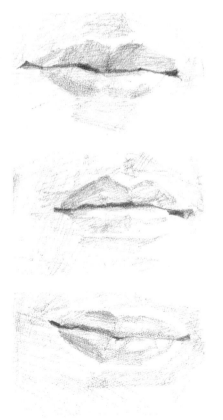

downward. The lower lip is lighter in tone because it catches more light. When the lips are held together, the shadow where they join forms the line of the mouth. This line disappears once the mouth is opened slightly. Viewed from the side, the lips are often very small – sometimes almost nonexistent – and it can be difficult to get the size and shape right from this angle. This is often more easily accomplished if the mouth is slightly open. It is important to note that there is no line around the lips, just a change in color and tone.

Three-quarter view Side view

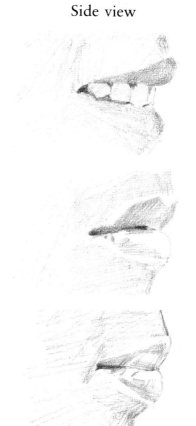

1 *Define lip line with mix of gray and red. Mix red and blue for shadows.*

1 *Mix crimson, blue, and raw umber for lips. Add raw sienna and white into mix for teeth.*

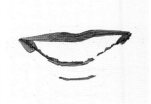

1 *Define mouth shape and lips with mix of red, raw sienna, and gray.*

2 *Mix red, yellow ocher and white for lip color. Add white and yellow ocher to this mix and block in skin.*

2 *Mix crimson, raw sienna, and white for mid tone on lips. Add raw umber and blue into mix for shadows.*

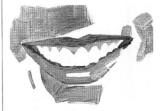

2 *Establish lips and gums with mix of red, raw sienna, and white. Add blue to mix for darker skin passage.*

3 *Add white into basic lip color and put in highlights. Mix yellow ocher, red, and white for palest skin color.*

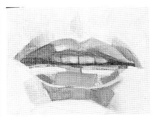

3 *Establish lip highlights with mix of raw sienna, crimson, and white. Add a little more raw sienna into mix and block in skin.*

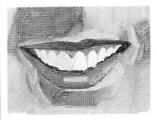

3 *Block in teeth with raw sienna, gray, and white. Mix lightest skin tone from red, raw sienna, and white.*

1 Define lip line with red and blue mix. Add yellow ocher and white and block in dark skin tones.

1 Define shape with mix of crimson, blue, and raw umber. Add white and raw sienna into mix for shadow.

1 Mix blue, gray, red, raw sienna, and white in varying proportions and define darks in and around mouth.

2 Mix red, yellow ocher and white for lips. Add ocher, gray, and white and block in skin mid tones.

2 Crimson, raw sienna, and white give a range of lip pinks. Add blue into mix for shadows.

2 Lighten lip color with red, raw sienna, and white. Introduce blue to this mix and block in skin mid tones.

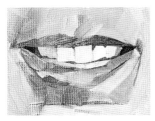

3 Mix red, yellow ocher and white in varying proportions for light skin passages and highlights along edge of lower lip.

3 Block in lightest tones with pale mix of white and raw sienna, with a little lip pink added. Use same mix for highlight on lower lip.

3 Work darker teeth with gray, raw sienna, and white. Mix raw sienna and white for skin, cooled with blue, which also helps give a transparent look to the skin.

Medium skin

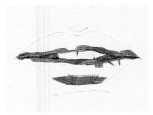

1 *Use gray and red to define opening. A mix of red, raw umber, and raw sienna gives darker lip tone.*

1 *Paint the line of mouth in mix of gray and burnt umber. Mix red, raw sienna, and white for dark of lips.*

1 *Paint line of mouth with mix of crimson and gray. Add crimson, orange, and white and use for lips.*

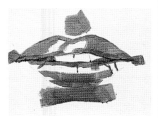

2 *Block in lip color with mix of red, sienna, and white. Add yellow and umber and use for shadows.*

2 *Mix gray, burnt umber, white, and some of dark lip mix and use for shadows and stubble around mouth.*

2 *Add orange, raw sienna, and white into lip color for skin middle tone.*

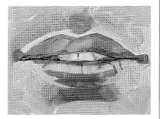

3 *Add raw sienna, yellow, and white into lip color for light tone. Add more white and yellow and use for pale line over lip. Add gray into mix and use for teeth.*

3 *Lighten previous mix with yellow, raw sienna, and white and use to block in skin.*

3 *Mix crimson and orange for light red on upper lip; add white into this and use for lower lip pinks. Lighten mid skin-tone mix with raw sienna and white and use for lightest tones.*

1 Define lip line with mix of red and gray. Mix red and raw umber and block in lips.

1 Define shape with gray, burnt umber, and raw sienna. Add white into mix and use for shadows at side.

1 Block in creases in skin, line of mouth and shadows with mix of crimson and gray.

2 Mix red, raw sienna, and white for lighter lip color. Add gray into this mix and use for shadows on skin.

2 Introduce more raw sienna, red, and white for skin tones. Add more red and white for light on lip.

2 Add crimson and orange into previous mix and use for lips. Add white and raw sienna for skin middle tone.

3 Add white to lip color and use for lower lip highlights. Block in rest of skin with a mix of lip color, sienna, yellow, and white.

3 Mix raw sienna, yellow, red, and white and block in lightest skin tones. Add in gray to knock back color on chin and upper lip.

3 Introduce highlights to lips with mid tone mixed with crimson and white. Lighten mid-tone mix with raw sienna, orange, and white and use for lightest skin passages.

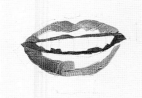

1 *Mix gray and burnt sienna for dark of mouth. Mix blue and crimson for lip color.*

1 *Suggest lips and line of mouth with mix of red, blue and raw sienna.*

1 *Mix blue and burnt sienna for mouth line; add burnt sienna and yellow ocher for dark of lips.*

2 *Redden lips with crimson, burnt sienna, and white. Add raw sienna and blue to this and use for skin mid tone.*

2 *Strengthen lips with mix of red and burnt sienna. Mix burnt sienna and blue for areas of shadow.*

2 *Add blue and white into mix and use for overall skin tone. Tonal range is limited.*

3 *Mix raw sienna, burnt sienna, and white and add a little blue for lighter tones. Highlight lips with crimson and white. Block in teeth using white mixed with light skin color.*

3 *Mix yellow and burnt sienna for edge of mouth. Add white and a little blue into this mix and use for rest of skin. Mix red, blue, and white for lip highlights.*

3 *Add yellow ocher and white into previous mix and use for lip color and area above top lip.*

1 *Establish darks in mouth and on lips with mix of gray, crimson, and burnt sienna.*

1 *Mix blue, red, and raw sienna for dark of lips and mouth line.*

1 *Mix blue and burnt sienna for mouth line; add crimson for dark of lips.*

2 *Define lips using mix of crimson, raw sienna, blue, and white. Mix burnt sienna and white for skin mid tone.*

2 *Lighten the mix with yellow and white for upper lip. Mix blue and burnt sienna for darks to use around mouth.*

2 *Mix crimson, blue, and yellow ocher for mouth line; add more crimson into mix for dark in lips.*

3 *Add raw sienna and white to skin mid-tone mix for lighter skin. Mix crimson and white for highlight on lips; add blue into this and use for gray base for teeth.*

3 *Add white into upper-lip color and use for highlights; add yellow into this mix and use for lights around mouth. Mix burnt sienna, yellow, and white for skin color.*

3 *Lighten previous mix with crimson, yellow ocher and white for lightest skin passages. Add blue to mix and use beneath mouth. Add more white and yellow ocher for lights around mouth.*

FLOELLA BENJAMIN

June Mendoza
30 × 65 inches

THE SHAPE AND FORMAT of the canvas were chosen to match the elegant stance of the slim model. Painted with loose, yet considered brushwork, the painting is predominantly cool, with a few warmer tones in the shadows of the face, dress, and jacket.

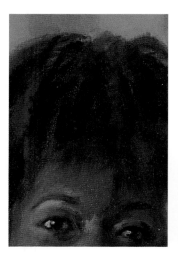

▶ *Yellow ocher, alizarin crimson, and white with a little ultramarine blue added give the reddish-browns on the lit side of the face. The middle tones are warmed by the addition of cadmium red and yellow.*

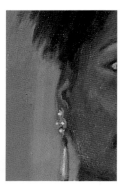

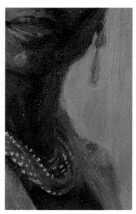

▲ *Only the reflections in the eyes are put in with pure white. The so-called whites of the eyes are mixed from skin tones, white, and gray.*

◀ *A dark blue-gray mix is brushed in under the chin and down the neck, indicating the effect of the reflected light from the pink dress.*

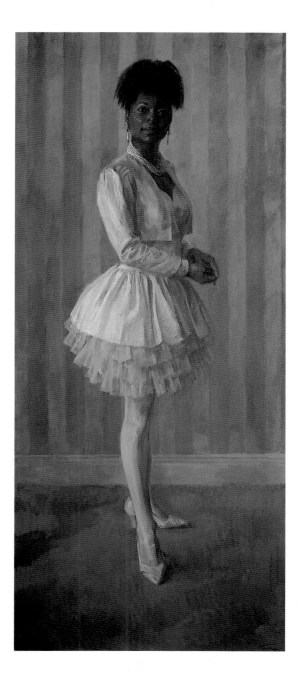

EARS

EARS ARE OFTEN hidden by hair, or are in deep shadow or concealed by the angle of view. The ears grow out of the side of the head – they are not stuck on – the front of the ear should flow into the side of the face without a break. The ears are fixed. They cannot change position or shape by muscle action, unlike the eyes, nose, and mouth. However, they do change dramatically as the angle of view is altered. Depending on the position they are seen from, ears can look completely

Full face view

wrong, so it is important to observe them objectively. Large ears that lie flat and close to the head will lose their ear-like shape when seen from the front, whereas smaller ears that lie at more of an angle to the head will be seen to retain their shape when viewed from the front. Ears are usually a deeper color than the rest of the face, due to blood circulation and the effect of shadows within the folds.

Three-quarter view Side view

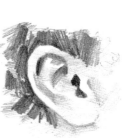

Light Skin Young

1 *Mix raw umber, red, and blue for darks.*

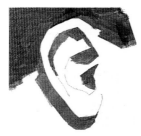

1 *Mix gray and burnt sienna for darks. Add crimson for folds of ear.*

1 *Mix blue and sienna for darks. Lighten mix with crimson and ocher to describe shape.*

2 *Mix yellow ocher, red, and white for mid tones.*

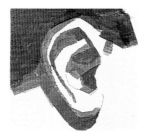

2 *Mix burnt sienna and white with a little crimson for middle tones.*

2 *Add white to dark mix for middle tones.*

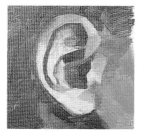

3 *Add white and a little blue into middle-tone mix and block in lightest tones.*

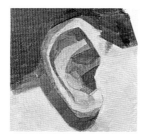

3 *Add white and yellow to middle-tone mix for lighter tones. Continue to add white for highlights.*

3 *Modify mid-tone mix with lemon yellow and additional white for light skin tones and highlights.*

1 Block in darks with varying mixes of raw umber, red, and blue.

1 Mix gray, burnt sienna, and crimson and use for darkest tones.

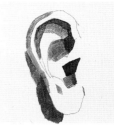

1 Mix blue and burnt sienna for darks. Lighten with ocher and crimson to describe shape.

2 Mix yellow ocher, red, and white plus a little blue for the middle tones.

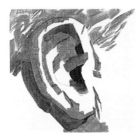

2 Add crimson and yellow into dark mix for mid tones.

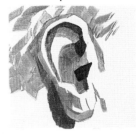

2 Modify dark mix with crimson, lemon yellow, and white for mid tones.

3 Modify middle-tone mix with white and use for lightest tones.

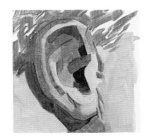

3 Mix white and yellow with a hint of middle-tone mix for highlights.

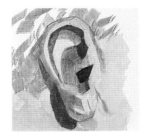

3 Lighten middle-tone mix with white and a little yellow ocher, and a touch of blue for light skin tones.

Medium Skin Young

1 *Mix burnt umber and blue for darks and suggestion of general shape.*

1 *Mix blue and umber for darks. Add red to mix for shadow behind ear.*

1 *Mix raw umber, red, and blue for darks.*

2 *Mix red and yellow with white and a little blue for middle tones.*

2 *Add yellow ocher and red to dark mix for middle tones.*

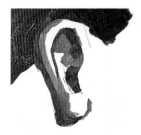

2 *Mix red, ocher, white, and a little dark mix for middle tone.*

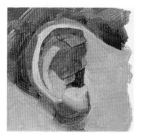

3 *Add a little yellow and white into mid-tone mix and use for lightest skin tones.*

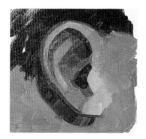

3 *Mix yellow ocher and red for lightest tones and add a little middle-tone mix to knock back color.*

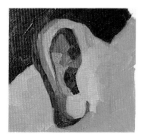

3 *Mix yellow ocher and red with a little white for lightest tone. Add in extra white for highlights.*

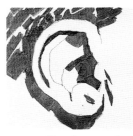

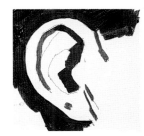

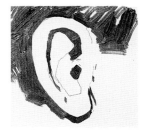

1 *Mix blue, burnt umber, and a little red for darkest tones.*

1 *Mix red and umber for shadows within and behind ear. Add in blue for darks.*

1 *Mix umber and blue for darks. Add red to mix for inside ear.*

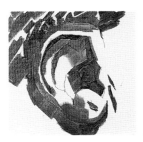

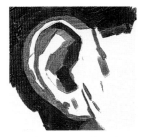

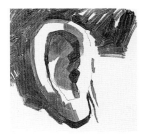

2 *Mix red and yellow with hint of dark mix to deaden color for middle tones.*

2 *Lighten mix with ocher and red, adding white to mix for opacity, for middle tones.*

2 *Mix red and yellow ocher for middle tone.*

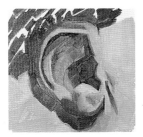

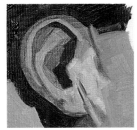

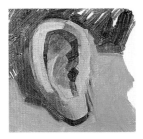

3 *Lighten middle-tone mix with white and use for lightest skin tones.*

3 *Mix yellow ocher and white and add in a little dark mix, and use for lightest tones.*

3 *Add white and yellow ocher into middle-tone mix and use for lightest tones and highlights.*

Dark Skin Young

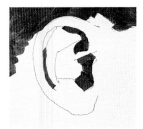

1 *For darkest tones of inner ear, mix gray and burnt sienna.*

1 *Mix blue, burnt sienna, and crimson for the darkest tone.*

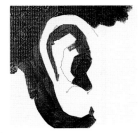

1 *Mix burnt umber, blue, and crimson for darkest tones.*

2 *Mix burnt sienna, raw sienna, and white with a little red for middle tones.*

2 *Add crimson and raw sienna into dark mix for middle tones.*

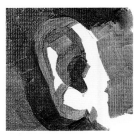

2 *Mix yellow ocher, crimson, and blue for middle tones.*

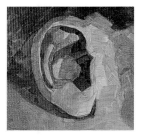

3 *Add raw sienna and white into middle-tone mix and use for lighter tones. Modify with gray and burnt sienna for duller color. Lighten mix with white and use for lightest tones.*

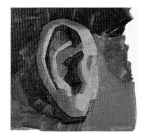

3 *Add white and raw sienna to middle-tone and use for light tones. Add a little blue and white to mix for highlights.*

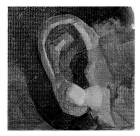

3 *Add orange and white to mid-tone and use for light passages. Mix this color with white and blue and use for highlight color.*

Middle-aged

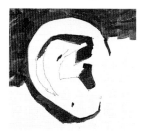

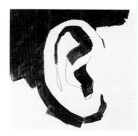

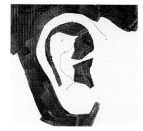

1 *Mix gray and burnt sienna for darks.*

1 *Mix burnt sienna, crimson, and blue and block in darks.*

1 *Mix burnt umber, crimson, and blue for dark tones.*

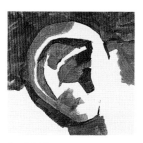

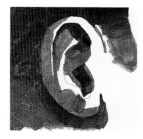

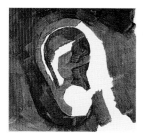

2 *Add burnt sienna, raw sienna, and red into dark mix for middle tones.*

2 *Lighten dark mix with raw sienna and white; add crimson and burnt sienna.*

2 *Add yellow ocher, crimson, and blue to mix and block in middle tones.*

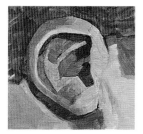

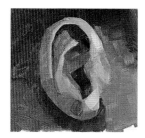

3 *Add raw sienna and white into middle-tone mix and use for lightest tones. Bright color can be subdued by adding a little gray.*

3 *Add raw sienna and white to middle-tone mix and use for lightest tones and highlights.*

3 *Add orange and crimson into middle-tone mix and use for lighter tones. Add in yellow ocher and white with a little blue and use for highlights.*

LYDIA

Ian Sidaway
45 × 54 inches

STRONG MORNING LIGHT pouring through a window on one side casts one side of the figure into warm shadow that is full of tone and color. Color has been bleached out on the side toward the light, so that side is painted in a less complex way with flatter color. The contour on the lit side of the face is hinted at by the cast shadow from one of the mullions on the unseen windows. Painted over a detailed drawing on a white ground, the portrait shows how strong directional light can give drama and added interest to a straightforward pose. The dark, uniform background serves to intensify the color on the figure and focuses the eye on the subject.

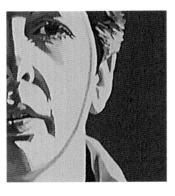

▶ *The skin color on the side toward the light is painted using a cool mix of lemon yellow, alizarin crimson, a little cobalt blue, and plenty of titanium white.*

▲ *On the leg beneath the skirt, the quality of the color comes not only from shadow, but also from light passing through the colored fabric. The tones are warmed with cadmium red and cadmium yellow.*

◀ *The highlights on the hair are created by painting carefully around them, leaving the white ground to show through.*

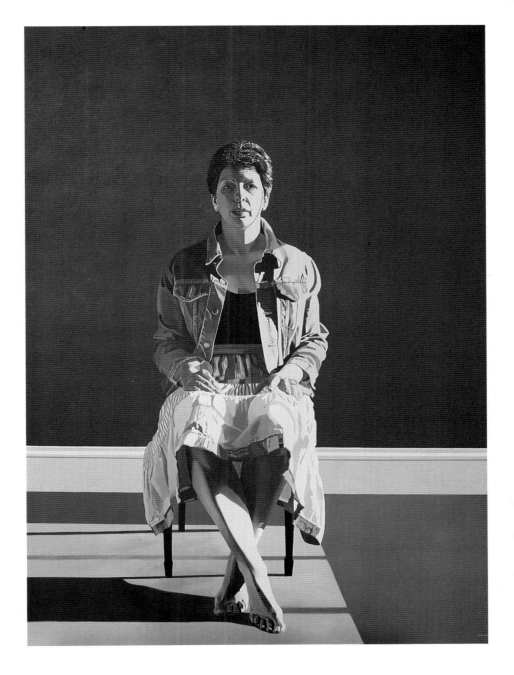

PULLING IT TOGETHER

FORM AND SHAPE are given to the head and face by the underlying shape of the skull, which is covered by a very thin layer of muscle. You can feel the contours of the skull and jaw quite clearly beneath the skin, which is not the case with other bones in the body. Skull shape varies from individual to individual, and there are distinct differences between ethnic groups. As the skull shape dictates the way our features are arranged, the variations in shape between one person and another explain why no two people look exactly alike. As a general rule, facial features in the young tend to be rounder and fuller. With age, the features become angular. The bones of the skull show more clearly beneath the surface as weight is lost and the skin begins to loose its firmness and tone.

With pale skin the shadows are cool, while in areas that are brightly lit the color is warmer. The reverse is true of dark skin.

From the front or in profile, the face and features can appear flat. The classic angle for painting is somewhere between the two.

The shadows on dark skin tend to be darker than on light skin, and highlights can appear to be lighter because of the contrast.

Light Skin

Young

1 *Gray and raw umber for very dark tones; lighten for hair. Warmer mix for forehead and neck.*

4 *Mix crimson, yellow, and white and block in middle tones on forehead, nose, cheeks, and chin.*

5 *Crimson, yellow, and white for lightest skin tones with white added for highlights.*

2 *Crimson, blue, raw sienna, and white mixes for shadows. Crimson, raw sienna, and white for lips.*

3 *Mix middle tone shadows with crimson, raw sienna, raw umber and white.*

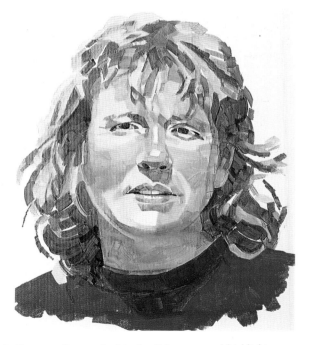

6 *Sienna, yellow, and white for light tones and highlights on hair. Alizarin and blue for shadow on sweater; add white for rest of sweater.*

1 Blue, raw umber, and white for dark tones in hair. Add crimson for the darkest shadows.

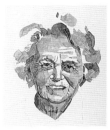

4 Mix raw sienna, yellow, and white plus previous mix and block in rest of middle tones.

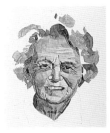

5 Add white to middle-tone mix for lights; extra white and gray for teeth.

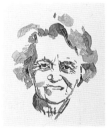

2 Add burnt sienna and white to previous mix for wrinkles; add blue and crimson for darker tones.

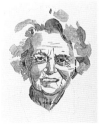

3 Raw sienna, crimson, white, and yellow for middle tones; more yellow for lips.

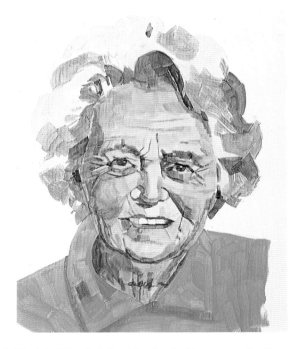

6 Block in lights in hair with mix of white, gray and yellow ocher. Mix burnt sienna, raw sienna, and white mix, for dress.

Medium Skin

1 *Use gray and burnt sienna for hair and lids; add more sienna for eye, nostrils, and mouth. Lighten with ocher.*

4 *Add white, ocher, lemon yellow into mix for middle tones, white and blue for lighter passage.*

5 *Add white to middle-tone mix for lightest areas. Mix white, ocher and gray for eye "whites".*

2 *Add more ocher for neck and face, add in red and blue for dark in lips.*

3 *Add ocher and white into mix for darker middle tones; add red for lips and face.*

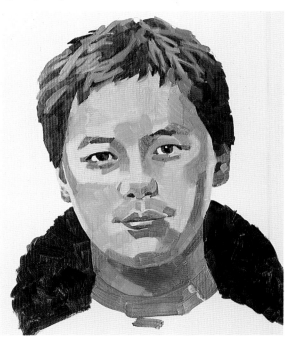

6 *Mix gray, a little blue, and white and use for highlight on hair.*

1 Mix gray, white, and lemon yellow for gray hair; mix gray, red, and sienna for darks.

4 Dark mix, ocher, red, white for middle tones. Lip mix, blue and white for gray tones.

5 Add white and lemon into previous mix for light tones, cutting around wrinkles and darker tones.

2 Add red and blue into mix for dark tones in wrinkles and on side of face.

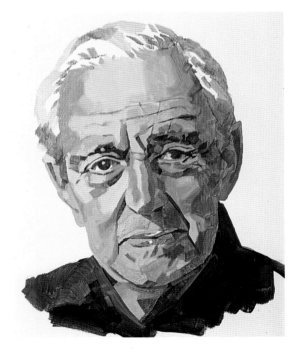

3 Add red and ocher to mix for shadows. Mix red, blue, white, dark mix for lips.

6 Add white to previous mix for lightest tones. Add red and white for lip color. Add gray into light mix and use for hair.

Dark Skin Young

1 *Blue and burnt sienna for darkest areas; add burnt sienna and white to mix for shadows.*

4 *Add raw sienna, yellow, and white to previous mix for rest of middle tones.*

5 *Add white and yellow into mix for light tone; more yellow and white for highlight.*

2 *Raw sienna, crimson, and dark mix for dark tones. Add crimson for mouth, nose, and eyes.*

3 *Add burnt sienna, yellow, and white for middle tones. Add crimson, white for lips.*

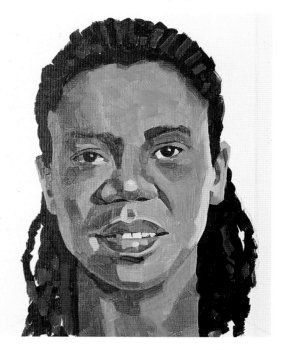

6 *Mix white with a little light skin color for teeth and white of eye. Add gray to this mix and use for lightest hair.*

1 *Blue and burnt sienna for eyes, nose, and mouth. Add more blue for neck and stubble.*

4 *For gray hair add white and gray into middle-tone mix.*

5 *Add raw sienna, yellow, and white into middle-tone mix for light tones.*

2 *Mix burnt and raw sienna and white for rest of darker tones. Add crimson for lips.*

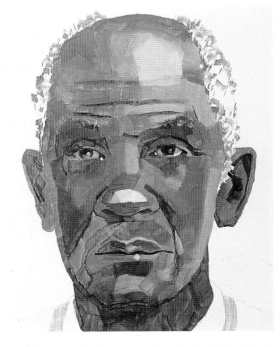

3 *Mix burnt and raw sienna, crimson, and white for middle tones across face.*

6 *Add white to light skin mix and use for highlights. Use light skin tone in eyes and add white for highnote on lips.*

Light Skin Young

1 *Establish darks using flowing strokes mixed from raw umber, yellow ocher, and gray.*

1 *Block in middle-tone mass with mix of burnt umber and burnt sienna.*

1 *Block in darks with mix of red, burnt umber, and orange.*

2 *Add a little yellow and white to previous mix for middle tones.*

2 *Add gray to middle-tone mix and work into middle tones to establish darks.*

2 *Mix orange, white, and red for middle tones.*

3 *Add more white to middle-tone mix for lightest strands of hair, blending with fluid strokes into middle tones.*

3 *Mix white and Naples yellow and draw in lightest strands of hair.*

3 *Add white and yellow to middle-tone mix for highlights.*

1 *Establish darks with quick strokes of raw umber, yellow ocher and gray.*

1 *Block in darks with varying mixes of gray, raw umber, and raw sienna.*

1 *Block in darks with mix of red, burnt umber, and orange.*

2 *Mix yellow ocher, raw umber, and white for middle tones.*

2 *Lighten dark mix with yellow ocher, white, and Naples yellow and block in middle tones following wave of hair.*

2 *Add orange and yellow to dark mix for middle tones. Keep brushstrokes fairly dry so that light of support shows through.*

3 *Redefine a few darks with mix of raw umber and gray. Flick in highlights using white mixed with touches of cadmium and yellow ocher.*

3 *Suggest lightest strands of hair by scratching out individual strands in wet paint with knife blade.*

3 *Lighten middle-tone mix with white and yellow and put in highlights. Use end of brush to scratch out individual strands of hair.*

1 Mix a dark brown from blue and burnt sienna for darks.

1 Mix gray and burnt sienna and block in darks with short, angled strokes.

1 Block in darks with mix of burnt umber and blue.

2 Add burnt sienna and yellow ocher to dark mix for middle tones.

2 Add yellow ocher into dark mix and cut in middle tones.

2 Add white and yellow ocher to dark mix for middle tones.

3 Brush on yellow ocher without blending for lightest tone.

3 Add white to middle-tone mix and chop in highlights with direct strokes. Do not blend.

3 Add white and blue into middle-tone mix for lights. Draw in a few individual hairs.

1 *Mix blue and burnt sienna for darkest hair and shadows.*

1 *Establish darks with mix of burnt sienna and gray.*

1 *Mix white, burnt umber, and blue for darker patches of gray hair.*

2 *Mix yellow ocher, burnt sienna, and a little blue for middle tones.*

2 *Add yellow ocher into dark mix for middle tones.*

2 *Add white and yellow ocher to dark mix and block in middle tones.*

3 *Thin middle-tone mix for lightest tones. Add a few "gray" hairs by scratching them out with a knife.*

3 *Add white into middle-tone mix and paint in lighter tones. Use handle of brush to scratch in a few graying hairs.*

3 *Add white and a little blue into middle-tone mix and put in lightest tone.*

Dark Skin Young

1 *Mix burnt sienna and blue and block in dark areas, following curl of hair with brushstrokes.*

1 *Mix blue and burnt sienna and paint in with fluid strokes.*

1 *Establish middle tones with mix of burnt umber and blue.*

2 *Add raw sienna and white into dark mix and brush in middle tones with twisting strokes.*

2 *Add orange and white into dark mix. Thin mixture and brush it over dark strokes for middle-tone areas.*

2 *Add ivory black into middle-tone and block in darks.*

3 *Mix titanium white into middle-tone mix, add a little blue and block in highlights.*

3 *Add blue and plenty of white into middle-tone mix and put in highlights.*

3 *Scratch in individual hairs with a knife blade.*

1 *Mix blue and burnt sienna for middle-tone curls.*

1 *Establish darks with mix of blue and burnt sienna, painting in wispy, flowing strokes.*

1 *Apply a thin, dry mix of blue and burnt umber for middle tones.*

2 *Darken middle-tone mix with blue and put dark centers in curls.*

2 *Add orange into dark mix for middle tones, and loosely brush this over darks, allowing white ground to show through as gray hair.*

2 *Add black into middle-tone mix and block in darks with thin, curly strokes, allowing white support to show through.*

3 *Add blue and white into mix and put in lightest tone. Leave the white ground to show as lightest gray hairs.*

3 *Add white into middle-tone mix and put in highlights.*

3 *Work over hair, scratching in lights and individual gray hairs.*

Color Chart

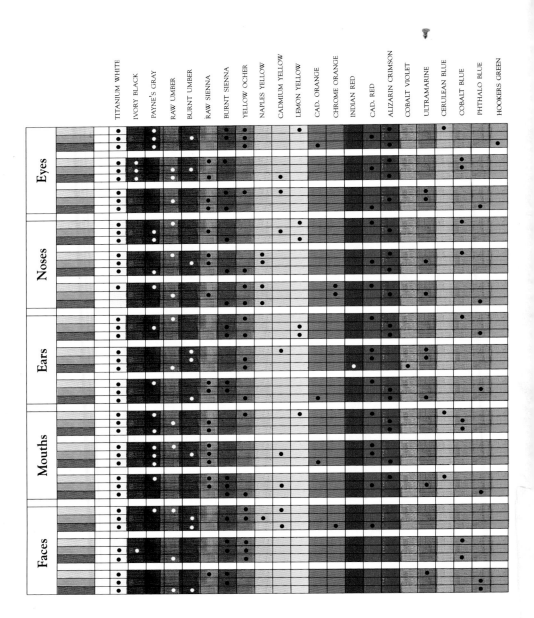